America Awake!

America Awake!

A Declaration of Interdependence

by

Thomas Jefferson and August Jaccaci

Daynal Institute Press
2008

Letters
Dedicated
to
Love,
the Source,
Substance,
and
Future of all Being,
the
Ultimate Freedom

AMERICA AWAKE !
A Declaration of Interdependence

by
Thomas Jefferson
and
August Jaccaci

Published by:
Daynal Institute Press
for
Unity Scholars

August 22, 2008

ISBN: 978-1-935187-07-3

Printed in the USA

cover image
"Jefferson"
© Jamie Wyeth

TABLE OF CONTENTS

Foreword .. i

Letters I-VIII.................. American Mentor and Prophet.......... 1

Letters VIII-XVI ... Life 17

Letters XVII-XXII Liberty 31

Letters XXIII-XXXII Happiness 43

Publisher's Note ... iii

FOREWORD

Thomas Jefferson, in these letters to Americans and the citizens of the world, is as always a radical and visionary idealist. He is also outraged at contemporary America. Yet, his assertions are in the end even more shocking for their spiritual optimism. On matters of the human soul and spirit, his thinking has evolved well beyond where he is remembered historically. He is also writing to us cognizant of our future as follows:

America means love.
The word America means love.
It is time, at last, for Americans to know that meaning,
and not a moment too soon.

Mr. Jefferson has returned for the year 2008, a critical election year to reawaken and revive the ailing soul of America. The soul of every human, every community and every nation is that unique inner consciousness which serves to navigate the living vessel of each life back to the safe harbor of reunion with the divine love which sent it forth.

Mr. Jefferson as the author of the Declaration of Independence and the social architect of the Bill of Rights is a primary guardian of the American soul. Under the terrible pressure of losing the American experiment in self-governance to the forces of fear trending toward fascism, Mr. Jefferson has returned to empower individual Americans to rise up to their full responsibility to protect their souls and their personal and community potential for fulfillment in truth, beauty and goodness which together express love, the meaning and destiny of America.

Mr. Jefferson's writings received at various moments on and after July 4th within the year 2007 are meant to be letters to all humanity. They are, however, focused on aspects of the American soul lest it journey farther from planetary potential toward planetary problem.

MR. JEFFERSON RETURNS

AMERICAN MENTOR AND PROPHET

Letters I-VII

Letter I

The Soul of America is at risk.

It is July 4th, 2007.

I am Thomas Jefferson returned.

I have come back for service to my beloved America. She is sorely in need of new vision, of a new beginning.

Dear Americans, I return to you in the voice and ideals of your tomorrow. I am sure you would take more comfort if my language were all pure colonial Virginian. That, however, is not at all my point or purpose in rejoining you. Better for you that I be the visionary calling to your natural dignity and destiny from your future and using such language common to you now that may lift and heal the soul of America. Yours is the moment, the turning point, or as you would say, the tipping point, of all human history since its ancient origins in Africa.

Americans have now a reckoning with human destiny. So I will speak to you in the words of now for the terms of your destiny.

For yours are the first few generations whose guardianship of all nature is a matter of your life or death down through all eternity. You may recall that I wrote that the dead authors of any document had no earthly right to bind up the lives of the living to their conceits. Rather every nineteen years each new generation is free and responsible to reconstitute its place in the world and of a right must do so.

Never in the course of human events has a moment occurred when America's redefinition of purpose and intent been more critical in cosmic dimensions. For you are the first humans ever to see the faint but emerging image of your own eternal extinction in the mirror of planetary nature.

Accordingly, I have come back among you to bring you the vision of your own natural maturation. In every human born is the potential for the parent, the mentor, the sage and the transcendent being, all stages of maturation now vital for your survival. I am

with you in all those roles so that you will express those capabilities as gifts your planet must have for the improving and enduring health of the whole family of life.

I suggest to you that you will have to develop a totally new political economy beyond democracy and capitalism in order to save life on earth. As with the work of the founding of the blessed experiment in self-governance, America, you will all become as we were then, social architects. Your artistry will become legendary down through the ages for you will have created a planetary renaissance on purpose in less than a decade. It is my current duty to help you find the design specifications for that emerging golden age of human transformation and transcendence now.

Dear ones, I would define social architecture for you as:

> Divine grace revealed in natural order used
> for the planning and enhancement of human
> fulfillment.

Divine grace, sometimes called the wisdom of the universe is, of course, love. The revelation of natural order is also always the discovery of love.

I have found from those among you the scientific general systems theory of transformative growth and change throughout all of nature. This revealed natural order makes clear that the tyrannical autocracy of King George the Third and his English aristocracy had to transform into American democracy, the power of the people. In the next progressive stage, the power of "We The People" will transform in your time into the power of all life on Earth. Soon thereafter, human political economy will transform again into the power of love.

By way of a brief farewell from this our first encounter, I offer you these few notes toward your emerging declarations of interdependence with all life:

A Declaration of Interdependence

When in the course of human events it becomes necessary for all people to separate from the cosmology which binds them and enter into a new cosmological understanding of the universe more primal in truth and fulfilling of their rights and needs, a common courtesy for all life requires that they state the reasons and causes that drive their separation and the discoveries that impel their maturation into new being.

We the people of Earth hold these truths to be self-evident:

All is created equal, sentient and sacred in love.

All being is endowed by its source in love with certain original rights.

Among these rights are conservation of being, creation of entropy for work, manifestation of symmetry for order and transformation by evolution for fulfillment.

These rights and principles of cosmic origin guide the people to institute new forms of self-governance based on new political economy in resonance with and reverence for the working of love in the universe.

Governments are instituted by people for people and of people with their creative engagement for the continuous care and fulfillment of all being.

When governments fail in these sacred duties of compassion, it is the right and the necessity of the people that they change their governments to bring them forward into harmony with the honest order of love.

In these notes, I have echoed my original declaration of independence to illustrate how radically different your present and future times are in comparison to ours at the birth of the American nation.

Letter II

I remember the birth of our first child and those who followed. There always is in the life of an unaware parent at the first newborn such an instant awakening and maturing into a new state of ceaseless caring love, as if all life itself had grabbed you into endless, exhausting, illuminating, fulfilling servitude. Other than the moment of your own birth and your own death, there is no such powerful moment as the arrival of your newborns. If you were life herself from all eternity, that moment of birth and parental maturation would be your principal purpose.

So when humanity as a whole being comes to that moment of awareness that all life on Earth is suddenly newborn, humans so quickly mature into ceaselessly compassionate parents of all life on Earth as to cause of themselves a change so monumental as to begin again a new calendar of creation.

Such a moment was the birth of the new millennium. Such a moment is the era of planetary renaissance now born of human transcendence. The inevitability of human maturation is as certain as that the mighty oak springs from the tiny acorn. The holy cosmos would have it no other wise, no other way.

Letter III

Nature is the architecture of love. This was so before the birth of your universe. It was love that slowed to descend into light which light remained to become matter which evolved to become you. So you are literally made of the love which descended and imploded to become the cosmos which word means order. Therefore, love is the order and intention and substance of all life. Now we are awakening to that reality.

It was always America's role in universal destiny to be the bringers of that light and that meaning. So the timing has now become right for Americans to be the source, the substance and the future of being love with all being.

Such being is not some distant form of holiness. It is a present form of practicality necessary for survival. Ideal behavior enacted in every snowflake, seashell, spider and star is Nature's ultimate form of practicality. That ancient truth from which our bodies are made is now coming home to the American body politic, and not a moment too soon.

I say again, America, and the word America, means love.

Letter IV

Over the years, I have taken some deep satisfaction that the phrase "life, liberty and the pursuit of happiness" has been understood worldwide as a definition of the great American experiment in self-government and as a call to the people of the world to free themselves wherever they are as a first step toward their own personal fulfillment.

So it is disappointing to me, nay, horrifying, that Americans today are more embroiled in the purveying of death than the glorification of life; more enslaved to war and oil and money than liberating themselves and the world's people to seek out their own soul's potential; more ensnared in fear of terrorism and fear of their own American government's enactment of torture and secret imprisonment; more worried about the potential outcome for their own citizens' brave and outspoken leadership than inspired and engaged in the pursuit of happiness.

It seems that America has been swept up in a regression of meaning toward a culture of fear and marched toward a destruction of the values of freedom on which the country was founded, values on which the world has come to depend.

That apparent regression and destruction signals a mortal wounding of the American soul. I write to the world's people by writing to you Americans to remind you all that human well-being out into the distant future is now dependent on your mutual and all-encompassing embrace of all life on earth, all liberty on earth and all happiness on earth.

That I suffered mightily through merciless editing of my original draft of the Declaration of Independence was no pain at all compared to my present pain at the prospect of losing our noble experiment in self-governance and the liberty of human fulfillment to the forces of self-serving, material acquisition and self- denigrating timidity of spirit running rampant today.

Letter V

America!

I say again your soul is at risk.

Fear is no foundation for goodness. Arrogant oppressive empire is no foundation for goodness. Greed is no foundation for goodness. Yet, the American soul is mired in these things.

They are curable.

But what do you do with a growing history now out in the open of premeditated preemptive war, war by choice. What does a soul do having committed such war falsely claiming self-defense? What does this soul now do for itself for atonement?

This is the American spiritual question of this political moment. Premeditated murder committed by any single citizen is the highest, the most heinous crime in the structure of civil law. What does a nation do awakening to the shame and guilt of such an atrocity of statehood committed in its name?

When the American soul finally awakened to the crime of slavery, it struggled through war to freedom climbing over the corpses of more soldiers lost than in all American wars combined. I was not man enough nor morally mature enough in my lifetime to fully face that primal challenge to life to liberty or to the pursuit of happiness and free my slaves.

Now the American soul faces a more primal challenge than ever in human history, for America is enslaved to war.

War, like slavery before it and still, is a human social invention, not an integral characteristic of human being like brain, bone, blood, psyche and soul. As such, war is a cultural artifice and political strategy inevitably bound for obsolescence as are the diapers of infancy left behind by the more mature child capable of conscious control.

There comes a day when war becomes so obviously dysfunctional and destructive of its own presumed purposes that the perpetrators of war find new behavior more beneficial to their true needs. That day has come to America. Yet it will take more

courage to admit it and to mature beyond war than to wage it. This challenge of American courage and character to renounce war and to invent planetary social harmony is the most critical issue of this moment of political searching.

It will be seen from the American future that the sacrifices and the valiance of American soldiers in Iraq and Afghanistan achieved the most noble of all victories in the over 230-year American Revolution when they were able with their deaths, their wounds, and all the horrors endured to bring to the American people, finally, the war to end all wars.

That is the victory of 2008 and beyond. That the only worthy atonement for premeditated war committed in your name.

Letter VI

Americans!

You are now slaves to war, put there into ceaseless servitude by less than a dozen men.

How could this be so?

How could this possibly befall a free people? Or had you slept away your freedom?

You seem to be totally powerless in the face of your supposedly elected representatives to free yourselves from any calamity – spiritual or natural. You can organize vast road systems and communication systems. Have you lost your eternal common system the human soul amid the buzzing business of your supposedly beneficent marketplace?

Where are you, Americans?

The world needs you to awaken again. Your most powerful and important political tool is your local living community. It is the only communal vessel where you can make your personal and collective intelligence strong enough and wise enough to start turning the new rudderless terrifying ships of state toward their only safe harbors of human wisdom and compassion.

Your voice is a whisper in a windstorm of confusion until you join it with your neighbors. If you cannot rise up in future health together, you will all suffer toward extinction alone. For extinction is the drumbeat now within the whole planetary family of life, and humans are the drummers of oblivion.

America does not mean sleeping through senseless murder. America means love. Rise up, dear Americans.

Letter VII

America is not a superpower. There is only one enduring superpower and she is Mother Earth.

When America, the greatest military and economic nation in history, turns to the abolition of war, one war-free community at a time, the United States military will become even larger and more valuable because it will transform into the business of living beyond the business of killing. In hundreds and hundreds of beneficial ways, Americans will do their national service in honor of living and life itself – everyone ready to give life to protect life but not with acts of premeditated killing.

This American victory of military maturation will be so courageous and triumphant, it will ring the bell of liberty throughout future generations celebrated in great gratitude. This victory, this abolition of war as an institution of foreign policy, will open the soul of all humanity to go forward to reunite the eternal environment with the essential economy, with what might be called the political economy of the entire family of life on Earth.

As with the new concepts of biology only a few decades old and standing for the study of life, Americans will lead the world in the invention of new words to mean the power of life, the meaning and value of life, and the transformation of capitalism into the optimization of all life on Earth. As with all profound maturation, the transformation of capitalism is a change of meaning and value from money and property to wisdom and health, from the obsession with the material to the celebration of the spiritual. This leap of growth has always been America's destiny, and it will return joy and pride to the wounded souls of all Americans.

LIFE

Letters VIII-XVI

Letter VIII

One of the clearest signs that a planetary renaissance is in emergent progress is that both life itself and the definition of life are struggling for redefinition and resacralization.

Renaissance means the rebirth of life.

Love is eternal sacrament.

Love and life are one and the same. The awakening to that unity is the defining nature of your emerging planetary renaissance.

There is now no sensible boundary excluding anything however small and ephemeral from the concept, identity and enactment of life. If, for example, you eliminated the photon of light or the particle of energy or the atom of matter from membership in the family of life, you would have no universe nor life yourself to consider. It is for this reason that I have declared for you that: All is created equal, sentient and sacred in love.

If the infinite eternal wisdom of love is embodied in light and in all that has emerged and derived from light including your own life, how could you possibly consider light absent from the family of life? Or any other necessary minuscule member of Cosmic Order?

Such expansive thinking is the mark and the measure of your emerging planetary renaissance.

Letter IX

The value of life is a principle of heaven. Since life is a sacred gift, learning its sanctity is the soul work of humanity.

Since the all too pressing need to eat and to drink seems superordinate in human life, you have no choice but to build your new political economy on that factual necessity. That reality is now mystery to humanity but reality to all other life. So the time has come in your struggle for survival to regain your reverence for the plants and animals and all forms of life which help make Earth your holy sanctuary and heavenly kingdom.

You are awakening once again to the unalterable demands of life itself. Your honest exploration of these devoid of the sins of greed and aggressive dominance will, in large part, determine your personal and public survival. For your current infatuation with money is soon to be swept into oblivion.

Financial collapse, a source of great personal pain to me in my final days, will be visited on all of you in the near future. You, dear ones, will garden your way out of crisis into celebration and salvation. Would that I had had the forbearance and wisdom to achieve your coming triumph.

I had the love of gardening, but not the wisdom of frugality and self-restraint that will mark your future success. For naught in the rest of nature except swine are overweight.

Letter X

As I have often said, the learning of the citizenry is the only defense against tyranny. The challenges thrust upon each generation require that they reinvent what they must learn and how they must learn it.

You, America, are now blessed with a new understanding that the stages of the ever-maturing individual life are also enacted in the stages of your collective social maturation. The citizen and his or her society must walk the exact same path as found within the general growth dynamics of the infant, child, adolescent, adult, parent, mentor, sage, creator and transcendent being.

Finding your place on this well known path of life enables you to plan your next stage and fulfill it with the greatest degree of excellence you can summon with your heart and soul.

And so, when the sacred American experiment in self-governance and the fulfillment of life, liberty and the pursuit of happiness comes to a crossing point to ford the transformative stream of life challenge and stage change, courage and honor demand the stream be crossed, however deep and swift the current before you.

Now the crossing to the safe parent stage reunion with all life is before you, and I am proud of the strength, hope and idealism with which you enter this apparently terrible turbulence, certain as I am of your triumphant passage to your noble destiny in higher love.

Your learning together is the sacred song of your social soul. Press on!

Letter XI

America!

It is alright if you let your current currency devalue to meaningless paper as long as you replace it with something of more lasting value.

You cannot avoid the cycle of all empires and nation states from agricultural beginnings, to industrial production, to service sharing, and finally, to pure monetary valueless manipulation where you are now.

The question at hand is whether alone in world history you can come back from your precipitous decline to ascend again to planetary leadership on the strength of new people-powered courage, creativity and compassion.

America never was so much a nation as it was an experiment in human aspiration and maturation. So it is fitting that your currency and your morality are in free fall in the world's eyes. For some lesser destruction always precedes some greater construction as I provided in my seemingly endless architectural struggles at Monticello.

However, if you fail in this hour of your decline to seize upon life itself on Earth and upon love itself as heaven on Earth as the way to create and enact your new political economy, you will have failed in your natural comeback and in your responsibility to the spiritual destiny for which you bear the name American.

Letter XII

The environment is the economy and the economy is the environment. So it has always been and is now for the world's traditional indigenous natives and for some of the world's farmers and fishermen.

Only since human industrialization of manufacturing and of farming and fishing has humanity lost that primal one-to-one relation between land and life. All that is on and within the earth's land and water and air is all that is on and within your bodies. Earth is your mother because you are conceived, born, and grown of her substance and intention.

Industrialization, for all its triumphs of replication of value, gets its power from fragmentation and standardization. Industrialization is the making of commodities for monetization. These forces which are the values and processes of industrialization diminish and marginalize the primal power and wild beauty of life and leave you lost and lonely, alienated from your soul's connection to the soul of Earth.

There is little hope for humanity's future if you do not venture to walk barefoot in the grass and bareheaded in the rain when your soul feels dull and lost. For the primacy of that simple joy is the pathway toward the joy of planting and growing something. It is the same joy as your affection for and from animals you care about. Slowly and surely, your heart and soul will come alive as these friendships with life widen and deepen. Simple as they are, these acts of kinship are the seeds of your salvation.

Grown all together, these seeds from all humanity will garden your planet into a springtime for the soul of the Earth, into a planetary renaissance, into a garden of goodness for all life.

Letter XIII

Salvation by integration of your citizenry, communion by community of the family of life, that is your American opportunity and destiny. That is your winning life strategy.

Conscious compassionate community is the soul of humanity, the species, as it is with all species, now and ever shall be.

Fulfillment of soul in service to life is the life worth living. Such fulfillment is the only true profit in any transaction. Such profit is achieved by the measure of creative and collaborative social union. Unity is your best freedom and your best vessel for the flourishing of infinite diversity, just as the hexagonal core of all snowflakes binds and promotes all their glorious unique differences of elegant structure.

Community is the fulcrum of human evolution in that the collaborative intelligence of a local citizenry of all living creatures and forms of growth will guide human health toward physical and spiritual maturation and soul fulfillment.

Letter XIV

The voice of the people, the power of the word We, the power of the people from whose consent and from whose strengths of combined wisdom governments are instituted and draw their authority, these precious contexts of political power have their natural home which is local geographic community. Not executive mansions, not the halls of legislation, not the courtrooms of justice but the community is the seat of the power of the people directly active in the determination of their rights, freedoms and responsibilities.

It has been rightly stated by Frederick Hegel that "Freedom is the recognition of responsibility." Ultimately, a citizenry cannot send away its responsibility for life, liberty and happiness in the person of some representative traveling to some center of supposed higher authority, be it state, region or nation.

There is no other species of life on earth that would give away the security and fulfillment of life to some distant member of its kind. It is precisely such taxation through distant presumed authority and presumed representation by members of the distant English parliament which caused the grievances that lead to America's fight for the triumph of independence.

Perhaps, in our founding, it was our fear of unlanded men and unempowered women which lead to their exclusion, along with slaves, to have the rights of political self-determination. Today such fear stands in shameful disgrace in the evolutionary march of political power forward into the necessary and functional care of the common good.

Today that march has come to the threshold of the doorway to the rights of and protection of all life on Earth. Therefore, there is no other seat of power for all life than the geographical and ecological community whose working integrity is its natural home.

Community, I say again, is itself in its creative interaction, the only true form of profit, for without its collaboration and

compassion, there is neither private good nor public common good. Community is now, again, as throughout all history, the setting of, by and for all life forms to live to mutual fulfillment.

Community is small enough so that its members may all know each other if wise enough, and large enough to be known by all life on Earth for its exemplary wisdom and beneficence to the common good. Treat well, therefore, your communities; for they are the new and emergent citizens of the world's politics of salvation.

Letter XV

In the long life story of local community, as old as any moment in the history of life on Earth anyone might choose to pick as a moment of origin, the ability of community to learn all together as one being, one organizational integrity, has been all life forms' creative strategy. Predation and parasitism are necessary dynamics in the struggle of lives to survive. But they are as small beings in the vast web of symbiosis. Symbiosis is the dynamic of living in mutual supportive harmony within, among and between all species. It is the predominant dynamic that has been the carrier of ever-emerging and evolving life on Earth. It might well be said that through all the annals of life, past, present and future, life is symbiosis. Of course, all life must eat however it can, but what it eats is the fruit of symbiosis, the fruit of mutual communal support and synergy.

So it is not surprising that there is now re-emergent a social invention returning humans forward into a new ancient form of communal learning, today being called a Communiversity.

In the years of the tenth and eleventh centuries what today you call the university was first formed and instituted wherein groups of students and teachers pursued an understanding of the universal essences and principles of all things in life. It is said by historians that the first such group in the nine hundreds AD met in Salerno, Italy to study the medical practices and principles of the ancient Greeks. There followed universities in Bologna, Paris, Oxford and Cambridge. In some measure and in hindsight, you might say these were early blossoms on the tree of knowledge signaling the emergence of the European renaissance.

Today, the Communiversity within the planetary renaissance is a new and different social invention in the history of human learning. For like the dance troupe or symphony orchestra, the whole membership of a community are all life- forms now learning to learn together in real time.

Such learning must of its nature be present to the continuous consciousness, consideration and compassion of the whole local family of life.

The family of life, excluding no life-form, is a new single student and teacher whose needs and whose priceless gifts are a unified and singular celebration. Learning as family celebration is an ancient wonder now re-emergent as a creative challenge. That humanity, of all beings, can host and honor this celebration is our happy destiny, it being that the rewards are so bountiful as to be scarcely imaginable.

Letter XVI

If you feel that you must vote your budgetary and other serious matters in the privacy of the voting booth, henceforth all done by the signatory touch of the pen to paper signifying your personal preference and commitment to social allegiance, save those issues which truly matter most for open public gatherings and town meetings wherein you can relish and glory in the power and sanctity of the human soul as your only enduring security and salvation.

For openly felt and observed community is your only true profit; and community enacted in the open is the soul of your society; and finally, in this time of terrible necessity for transformative change, community is the fulcrum of human evolution. Depending where you place the public fulcrum in your community, the weighty considerations of just a few citizens can lift the weight of all humanity in the service of all life.

LIBERTY

Letters XVII-XXII

Letter XVII

The transformation of the blessing and idea of liberty, freedom from political tyranny and dominance by humans of each other, to the freedom for the natural wildness of all life forms on Earth is new for humanity in this time. It is not new, of course, for traditional indigenous peoples who consider all other life to be their family relations and kinfolk.

As the number of humans on Earth continues to increase, wild land and free running water, your family relations, are losing their liberty to the tyranny of what you call necessity. You put yourselves into endless slavery when you enslave and destroy the wildness natural to all life around you. You enter a desperate dungeon and throw away the key when you can no longer breathe with your wild kinfolk in celebration of life.

It is to your everlasting credit that you are ever more vigilant in saving evermore land and water from destruction. Yet, you have barely begun the process of regeneration and purification of the land and water now in controlled subservience to meet your bodily needs. When you learn that all wildness of all life in any state is yours to protect, that its liberty is worthy of your care and reverence, you will have matured in your own liberty. That is the life and liberty of your time. That is the pursuit of happiness which is your salvation.

Letter XVIII

Dear ones, only innocent, unaware children would believe that a national Supreme Court acting to the best of their abilities would be worthy of the right and capable of the judgment to award personhood to corporations, presidencies to unelected persons, and ownership of the architecture of all lives on earth to private owners calling life itself their personal property.

There are realms into which the noble structure of civil law with all its benefits toward social harmony should not and cannot possibly enter. It is impossible to legislate the meaning of nature's souls and the holiness and sanctity of those souls' stories. Civil law reaches its fulfillment and highest good in protecting opportunity and possibility, not in dictating the specifics of their future outcome.

A soul is that attribute and that capability common throughout the full family of life which is each life's compass toward divine reunion with its Creator. The home port of reunion with the divine is the deepest yearning of every soul. That journey, that story cannot be judged in a court of civil law any more than an innocent newborn child can be blamed, tried and burdened with the sins of long past or longed for future generations.

When actors from the realms of civil law trespass into realms of morality and spirituality wherein they have no right nor ability to pass judgments, the people sensitive and strong and enlightened enough to recognize these transgressions must step forth and rescue the common good and the whole life social harmony from such criminal presumption.

Healing transgressions enacted within the realm of civil law cannot be controlled and purified from within the same domain of civil law in which they were created. Parents who venture out away for an evening's entertainment from home do not leave their young children in the care of other young children. They seek older, more experienced and dependable often best enacted by the childrens' grandparents.

Supreme Court justices cannot be cared for by others of their kind and station in life. Only older wise elders and often the collaborative intelligence of groups of caring citizens can properly call justices to account and to compassionate question and consideration.

Failure to call justices and their legislative and executive colleagues into question when they are building elaborate fortresses against cosmic common sense and the natural ways of souls throughout the family of life, is to destroy the last best hope of harmony enshrined in the American experiment in self-governance.

Letter XIX

I have no right to speak to you of excess. All my adult life I lived beyond my means ending my years so deeply in debt as to be powerless to pass on anything of consequence to my progeny. Most importantly, I lost ownership of my slaves so that if I wanted to free them I could not.

Perhaps it is the shame of my final years, however, that qualifies me to warn you of excess, you whose lifestyles and whose transnational corporations are so compulsively gluttonous. For by military might, not right, and business cleverness, not kindness, you control and consume five to ten times every day more than your share, by your percentage of world population, of the world's riches.

Americans are less than five percent of the world's people. You consume twenty to fifty percent of its riches daily. Most of the world's people live on less for a year than some of you spend in an hour. Even just among yourselves, your corporate leaders now earn more in an hour than their own workers do in a year.

There is nothing more shocking in our nation's history than my own ownership of slaves. Yet today, Americans suffer the rest of the world's people and all other life forms to live enslaved to the thoughtless gluttony of a very few whom you glorify for their excesses in your magazines and media. Monetary wealth has so captivated the hearts, souls and dreams of Americans as to totally disassociate your lives from worthy membership with all other lives and life itself on your planet. It is estimated that it would take four planet Earths to provide all of humanity what Americans consume daily.

Freedom, that priceless American ideal and virtue for some has now become freedom from you, not with you.
Freedom from American and similar gluttony is now the life and death struggle of all life on Earth. For it is said by thoughtful scientists among you that at the rate of ruination of the planetary environment accelerating as it is, half the species here present

today will be extinct by the end of this twenty-first century. Almost all the world's largest corporations that are these ravenous killers are American. Of course, there are many others and other rich persons worldwide. Yet America is leading the charge of global gluttons marching toward human extinction. Human extinction is now emerging as a possibility, as an image in the mirror of planetary nature. America has begun the act of human suicide without knowing it.

The struggle for freedom from England's tyranny in our nation's founding is an important moment in human history. Yet, it is as naught compared to the founding of a new planetary civilization for the salvation of life itself on Earth.

America is a comeback people. Comeback is the archetypal action defining American character. If there ever was a moment in the long several million year history of humanity now right for a comeback to salvation, you, America, are living in that moment. You, America, are the world's problem; so you are the world's solution.

I am sorry to speak so harshly and with such spiritual excess. Yet, I feel there is no other choice if I am to awaken you to leadership in the creation of a planetary life renaissance so fulfilling of your natural destiny.

Letter XX

Money is the corruption of the American soul. I could see it coming with the visions and machinations of Mr. Hamilton and the Northern industrialists. They without apparent care for what they were destroying subverted and seduced the American connection to pure wilderness and the bounty of all land. They tore from the land her humble farming people and enslaved them in the new dark satanic mills. Humanity has never known such a fall from grace, save the New England slave ships themselves.

Now we come again to the American experiment falling into enslavement to the corporate domination of nature's beneficence commodifying into produce for monetary profit every living thing on earth capable of capture or unholy harvest. The daily gambling casino you call the stock market keeps a ruthless score as destructive to the spirit of life as you could possibly have invented.

The prideful and punishing murder of Hamilton by Burr was a tragic depiction of sins to come where nothing was harvested but shame and guilt. America duels with all the world's lives and never loses. She stands in her soul behind such a long string of subversions and assassinations in the putrid politics of military industrial domination that all life on Earth now shudders in horror as it prepares itself to fall to the blade of the scythe of death which has become America.

First by far in profiteering in the war and death industry, America yet is still the global seat of benevolence and idealism. Such a soul-wrenching struggle for clarity and purity of purpose human life has never seen before. The depth of the mystery of how good and evil could so inhabit a single soul seems to have rolled in like a thick fog from the ocean of human evolution. The American soul is desperate for the burning power and purity of sunlight, the sunlight of spiritual transcendence.

It feels like an endless hopeless night of blinding murder among you. Yet, dawn is inevitable. There are those Americans among you still, first alone and then in small villages and towns

and city neighborhoods who are rising early in courage to be bringers of the dawn.

I am reminded of the midnight ride of Paul Revere calling our country to the fight for freedom which today has begun again. If money is your purpose, early death to all life is your certain end. This time you fight the forces of eternal extinction. Rise up! The dawn is at your door.

Letter XXI

The importance of energy in modern life, which is a desperate fixation causing political strife unto state-condoned murder and causing public pollution of air, soil and water, is about to be importance transformed to gentle moral transcendence. For energy throughout the cosmos has always been free for the taking for use in formative processes from galactic gatherings to plant and animal growth on Earth.

Energy is not force. Force amid the human story is the focusing of natural free flowing energy into technologies and tools that empower our creations and our destructions. That so much of your contemporary forcefulness is choking you to death with respiratory illness from excessive burning and poisoning you to death with chemical and atomic toxicity is a commentary on your moral immaturity and militant mediocrity given the free energy common to all formative life in the cosmos.

Force which reaches its pinnacle of pride, power, and arrogance in military weaponry would be comic in its childish, thoughtless, playing with death were it not now that the children have set fire to the house you call home, our planet. That human ingenuity driven by fear and greed has become your chosen form of eternal suicide in the face of unrecognized or unaccepted freedom of energetic life- enhancing success makes the predominance of death-play a human mystery.

So it is a moment of even more mysterious grace when the natural transcendence of natural human maturation carries your behavior forward from raging warring childhood to the moment of parental wonder at the moment of arrival of their first newborn child. Humanity is growing up. Humanity is learning a new depth of love and continuous caring from its newborn infant. That infant is our planet. That parent is humanity.

More than any other story, the freedom from thoughtless force to the freedom of expressive planetary kindness and compassion is playing out in the awakening hearts and souls of

Americans. It is a struggle between force and freedom, how you are again releasing one to champion the other. Force does not win freedom; from human birth onward force kills freedom.

If freedom is America's essence and primary passion, her discovery of the new forms of the universe's free energy will become the forming of the social architecture and the laying of the foundations of planetary social harmony with and for all life.

Free energy is the key to the kingdom of transcendent maturation and successful conscious evolution planned and performed by the children of hope, Americans, now the parents of hope, Americans.

Letter XXII

Global warming will transform to wisdom weather when you learn to plumb the depths of spiritual creativity, in other words, harvest the precious gifts of each distinct stage of human life and form a new political economy on those gifts.

Monetary capital is dross and the concept of human capital is the ultimate insult to the angelic purity of the newborn infant. If you would have greeted the newborn Jesus the Christ and all other holy ones of the world at the times of their birth as monetary investments, you might have been able to save some two thousand years getting to your current state of disgrace.

Conversely, dear ones, and you are ever dear, recall the words of your eternal friend Jesus when he said, Behold the lilies of the field, they toil not nor do they spin, yet Solomon in all his glory is not arrayed as one of these.

A new kinship with all life awaits you and a new coinage of spiritual purity is yours for the minting. Behold the innocence and trust of the infant; the playful creativity of the child; the searching yearning of the adolescent; the fertile fecundity of the adult; the loving care of the parent; the soulful compassion of the mentor; the firm foundation of the sage; the magical mystery of the creator and the holy reunion of the transcendent human.

If you cannot build a new political economy in marriage with all life from this vast treasure of what it is to be human, eternity would be surprised and confounded. I have the great good fortune to know that you will.

HAPPINESS

Letters XXIII-XXXII

Letter XXIII

Happiness like love is not something you do, it is something you are. Its increase in your life comes from the increase in your service to life given freely and on principle. The principle is realized in your experience of the fact that love is its own reward. Once your life is at liberty to enact the love which is your soul, you have achieved the pursuit of happiness without trying.

That is the next experiment in the great American experiment, that emanation and expression of individual and community love whose natural by- product is happiness.

You live in a miraculous moment in human history. It is the moment in which humanity as prophesied awakens to the experience that love is infinite in experience and meaning made so by the fact that love is the source, the substance, and the future of all being. It is the moment when human cosmological discovery matures from concentration on the behavior of energy in the universe great and small to the discovery that love is the source and cause of all lesser forms of energy from gravity to electricity to politics and economics.

To be alive at such a moment makes responsibility for the future of humanity and the Earth family of life an unrivaled joy, feather light and seed light.

The transformation of your worry about the fearful future of humanity into joyful creation and design is a transformation which embodies and exemplifies the divine grace which is the universe and your life within it.

Letter XXIV

Transformation is the product of radical subtraction and heavenly regeneration. It is the stuff of revolution and evolution.

To be conscious transformation is the role and the honor of the social architect. To be that person, that designer, in the age that now enfolds and embroils the masses of humans in confusion is a pivotal challenge for you and a responsibility which you dare not avoid.

The transformation of social architecture to include and become sacred architecture is none other than the most courageous and radical act in American history, far more ambitious of reach than any act in our nation's founding. For that reunion of the holy with the human health not only reunites science and religion, resolving that needless and senseless squabble, but it also reunites the heart and the head which have no place henceforth in opposition.

Holiness and health are the same thing. To seek wholeness is holiness. It is to seek the highest form of health there is. Throughout all of nature this is true. Health is not a commodity to be bought and sold; it is a divine right not to be stolen or denied by anyone for any reason.

The ability of humanity to subtract money and war and property from their places of central value in contemporary life is a matter now of death or life for all eternity for all humanity. The cosmic magic, the divine grace of heaven on earth, will return these power and possession diseases of the modern soul in rare, purified, healthy, and holy new forms for those social architects courageous enough to trust the founding order of transformative life in the universe.

Transformation is grace. It is your life. Where do you think your life came from?

Awake, dear ones.

Letter XXV

Health is the new wealth, the challenge and the battle of this century.

Health may be measured by wholeness, vitality and unity which are the principles of all life. Unity with all else is life. Its absence is destruction. Vitality may be measured by active creation, not the objects of the creation. Wholeness is the membership with all else by making a beneficent life contribution to the community of all being.

Healthy community given freely to all its members is an essential freedom and right of every species in the whole family of life.

So in the end of all efforts and enterprises, whole healthy community measured by the depth and honesty of its generosity is the only possible engine for the continuity of well-being. Anyone or any group who puts themselves between life and its health is a gatekeeper of hell.

That the people know this in America is certain. That they have the strength and courage and political health to rid themselves of parasitic death-dealing is in question.

Again, the solution to all difficulties and acts of injustice returns to the local community. All other higher authorities are so constrained by corruption and greed as to be unworkable for the restitution of justice and simple human kindness. So it returns to the local community to feed, clothe, shelter, educate and heal itself taking whatever pains necessary to fend off the intrusion of governmental and corporate greed, corruption, and death. Then in unity, vitality and wholeness the communities of America, self-sufficient, self-reliant and self-governed, will weave the web of safety and sanctity for which this noble country was founded.

Letter XXVI

I had a passion for design in my day which is still with me. Design of all human endeavors can get out ahead of history, and if the design is elegant and ultimately sensible, it will pull humanity into its beneficence.

So, America, you are faced with the design of a planetary renaissance to benefit all life on Earth. You have no choice, therefore, but to choose your design principles from among those universal and eternal principles that serve all forms of life for all time. This means putting aside all such contemporary considerations determined by and aimed at money since nothing else in nature uses money nor can eat it.

Underlying the phrase life, liberty and the pursuit of happiness are universal and eternal principles of value to all forms of life.

The principle of conservation is one such truth and it is, in fact, the fundamental truth on which the entire enterprise of science is built. Conservation means that energy can neither be created nor destroyed, only strangely moved from one state to another, as ice melts to liquid. Conservation means, therefore, holding order in nature inviolate so that it can change form without loss. Holding lives in biological and in energetic nature inviolate so that they can exist to grow and change and transform is to enact the principle of conservation consciously. Behind, beneath, and within the principle of conservation is the eternal principle of love, the ultimate conservator.

In apparent contradistinction to conservation is the universal principle of entropy, the dissipation of energy for the accomplishment of work. The spending of energy toward its continual apparent loss and decrease is as necessary as that destruction and decay must precede and empower creation and construction. Where else would come the lumber from trees enabling the building of your home. Yet that home provides a truth about entropy: that energy which appears to be spending and

dissipating is actually allowing and providing for the formation of emerging higher order in the home itself. It is
true throughout nature in the crystal, the honeycomb, the bird's nest, the beaver pond, that energy spent, entropy, provides the ideal form that always does more and more enhancement of life with less and less energy. Entropy ultimately traps and conserves energy in a new form of higher order. Work spent in nature hosts life more ideally. The work formings in nature are a design idealism which is the mother of all practicality. Look, then, to nature for the working ideals of design, the eternal archetypes of eternal order.

Symmetry is another of nature's favorite universal principles and design eternals. The human body is a masterpiece of bilateral symmetry. The same ordering is all-pervasive and productive throughout countless other life forms in nature, providing their physical means of livelihood and locomotion. Symmetry underlies all the correspondences of words and their referents, numbers and their quantities. Communication of any kind is a projection and reception of symmetry. So the use of careful symmetry in the creation of relationship with, between and among life forms and energetic forms on Earth is an enactment of resonance and reverence with all life. Symmetry is not design laziness, it is a higher order necessity. Symmetry is the manifestation of the eternal principle of Creation.

Finally, in this group of four universal principles common to all life, there is the principle of information writ small, evolution writ large. Information and evolution are how nature finds and retains those differences which make an enduring difference. There is a natural progression of increasing order exemplified, in human knowing, when information transforms into knowledge which transforms into wisdom which transforms into love. There is a natural rolling and rumbling like thunder bringing blessed nurturing rain when human design matures in intention toward the planning and enhancement of human fulfillment in love. Then you are the embodiment as social architects of the eternal intention of

the order you call cosmos.

If you want to more deeply consider or understand any of these universal design principles, conservation, entropy, symmetry, and evolution, you will be assisted in examining that any one is formed by the union of the other three.

It is a source of great joy to me knowing as I do that you are becoming the social architects of the first planetary renaissance, you Americans and your growing family of friends in the full family of life.

Letter XXVII

The eternal actions as principles behind the birth and forming of the universe are yours for designing the social architecture of your planetary renaissance. They are the eternal principles of love, creation, order and evolution from which derive your scientific principles of conservation, entropy, symmetry and information, your universal principles common to all forms of life on your planet.

There was one recently among you, Robert Buckminster Fuller, who called for a design science revolution to afford you the ability to get out ahead of human evolution and help guide you and all life into a higher order unity. He was fond of talking about the synergy within steel and how steel built the modern era of skyscrapers and airplanes. He was the Leonardo da Vinci of modern times, yet he said for you that love is the steel of the twenty-first century. And so it is.

Yours, then, is the opportunity and honor to become the guidance given you from St. Francis of Assisi who had said to you that love is infinite in experience and meaning. How could it not be; it is the source, the substance and the future of all being. So if you would build anything, build it on a web of love and it will be both ephemeral and timeless, momentary and enduring.

Letter XXVIII

There is an order to all things in the universe which guides the affairs of all humanity. That order is so fundamental that it formed the nature of the evolution of the universe itself. That order brings the descent of divine love into the first burst of eternal light and that light into the formation of first matter. From love to light to physical substance, so you humans are formed and have your being as exemplars and models of the entire cosmos which word means order.

You are descendants of love. You are climbing your souls' ascent back to reunion with your creator and creation authored in love by love and for love.

This descent from divine intention and ascent returning to it is your way, your wonder and your work. When a planetary generation of humans awakens to this cosmic order and intent, and when your lives become an enactment of that love's intent, you have become a new political economy, the first cosmic community in the history of all humanity, all humanity.

Cosmology, your understanding of how and why the universe came into being and you within it, cosmology is the largest and most powerful thinking tool and story humanity has, and all meaning in your lives derives from it and is ordered by it.

These are such times, then, when human life on Earth becomes worthy to befriend all life here around us and within us, worthy and wise enough at last to carry love out into the galaxies of the heavens. This maturation in life and love will open the door to reunion to other life in the universe, it being Earth's destiny to carry the founding order of the cosmos out into the stars.

Love is not something you have to do, it is something you cannot help but be since the substance of your very bodies is made of the love become light become matter of the first instant of the manifestation of the cosmos. You are the stuff of love awakening to return to our original heavenly home.

In a matter of a mere few years, our political economy on

earth will free itself from the monetary clutches of either-or exchange; either you have the money or you exchange it for the objects of your desire. More recently with the emergence of information as a medium of primal importance you have begun to mature toward and-and exchange. When something is learned both the teacher and the learner still retain it, and as it is passed along to others, everyone retains it and there is no loss, just social synergy powered by information trending toward wisdom.

Love, that cosmic miracle of divine grace, requires no exchange, no reciprocity. Love is its own reward. The inherent beneficence of love is its own reward. You do not do love, you are love. You can not help but be the cosmos for the cosmos.

Letter XXIX

Fractals are the visible signs of Nature's frugality of creative process. When it takes her millions of years to grow and continuously refine the elegant fern, for example, why would not the fern be an example of every tiny leaflet taking the same shape as the leaf it helps form and every leaf taking the same shape as the whole fern frond it helps to form. That self-similar form within form that nature uses in growth you, today, name fractal.

Human ideas are fractal reenactments of the birth event of your universe. When the idea of love slowed its timeless and eternal vibrancy to explode into light whose speed is now the natural vibrant frequency of your physical universe, a process was begun which is also now used in human scale for the manifestation of an idea into human behavior. Human ideas are reenactments of the birth moment of the universe, fractals of cosmic order.

I tell you this so that you will grow in reuniting with your source in cosmic order and realize a new cosmology which is also your new political economy for the planet you inhabit, free of thoughtless killing.

When a human idea of infinite speed everywhere in the universe instantaneously without travel time has to slow down to become electric impulse in your body to create intention, action and behavior, a spark of light appears over your head to enact the birth moment when that idea becomes visible manifest reality in your slower light-speed and electric-speed world. You are your universe of love in every instant of your divine life. Imagine and become that divine inheritance.

Letter XXX

You are the salvation generations. Some generations win impossible wars against impossible odds. One generation among you broke the spell of holy Earth and walked on her moon.

Now you are in the process of learning how to partner with and parent with all of Nature. This does not mean exercise the morally immature disgrace of pretending to own the formative architecture of organic life. It means to honor and to love the long, long story of wildly various forms of life emerging, growing, changing, and moving on. You are salvation's darlings because you will decide to remain for countless generations into the distant future as parental lovers of all life.

Now there are more and more among you who are choosing one or more species of life: frogs, corals, birds, trees, fish, animals of all kinds to befriend, protect and enhance. For you are on the road and passage out into time and the galaxies ahead as ambassadors and emissaries of love.

Love is the galactic export of Mother Earth and you are her saviors, the salvation generations, and a galactic gift to universal and eternal truths for which the universe itself was born as a living being. The cosmos is itself an experiment to see if love, its source and substance, can awaken to consciousness and then be self-realized and self-fulfilling.

Think of the honor and the glory you now have to be those humans who were chosen and chose themselves to tell that cosmic story beginning on one beautiful spot, America, on one bounteous beautiful Earth.

Letter XXXI

Political economy, scientific technology and physical cosmology are all reciprocal causal. That is, they all three cause each other to become and be what they are.

Of the three, physical cosmology is the broadest in the dimensions of its meaning but is dependent on a platform of political and economic support and on an extension of human scientific knowledge and technical reach for its ever-changing regeneration and redefinition.

As promised to you at the outset of these letters of attention to America for all humanity to consider, I said I would be speaking to you in the terms of today about the triumphant accomplishments of your future. Far and away the most soul- shocking, yet life-saving discovery you will make is that the physical energy and spiritual intention of love, one and the same, is the source and the substance of the entire universe of matter and consciousness.

In the manner in which light and electricity are so central to the contemporary process of scientific research, love will be the new central power, source, and purpose of new technical, conceptual and social inventions.

In the manner in which meaning and money are so central to the contemporary process of politics and economics, love will be the new central value, source, and purpose of new environmental, biological and cultural relations.

In the manner in which energy and matter are so central to the contemporary process of physical cosmology, love will be the new central spiritual intention and purpose of new familial, societal and universal transformations.

That these last three paragraphs are identical in the structure of their process signaled for me as I wrote them that they speak of a grand unification for all humanity. This unification achieves a new harmony for all life on Earth while simultaneously providing a platform for the continuous unfolding of infinite diversity.

Letter XXXII

As a farewell to you blessed Americans and all your planetary brothers and sisters of all peoples and all species, I offer you one final set of insights on your design of the inevitable planetary renaissance it is your destiny to begin.

Spirit in design is how grace enters culture. I have learned this new social architecture perspective from St. Francis of Assisi who, because of the depth of his love, has become another of your and my mentors in the tearing down and building up of holy home; of higher more perfect union, of heaven on earth.

You really have no choice but to heed his words if human continuance, maturation and fulfillment are to be your future.

> Love is the Breath of God,
> The Matrix of all Spirit and Matter,
> Life and Growth.
> Love is the carrier of light
> and all the divine order
> and purpose we can ever know.
> It is the symbol and the story,
> the letter and the word,
> the energy and the law,
> the particle and the wave,
> the idea and the form.
> To know it as the experience
> of these things and in all our human relations
> and all else we experience
> is the will of life itself, which life
> is the mysterious Breath of God,
> Holy, Holy, Holy and eternal –
> on loan to us of willful Earth.
> Will we breathe the One?

Publisher's Note

The words written upon these pages call for an expansion of our soul daring to embody more vividly the knowledge and wisdom of love. Their influence will be more readily available to those maintaining a focus upon the actual message without a preoccupation with any apparent messengers who have borne the expression in this particular form at this moment. Otherwise, the inertia of a familiar logic attributing the 'authorship' to a personality locked into a temporal and spatial grid, whether it be Thomas Jefferson, August Jaccaci, or perhaps Francis of Assisi, will miss the single most important point in this writing, namely, that the 'source' is One dwelling in the timeless depths of all persons endeavoring now to write an enduring charter of freedom directly upon the hearts and minds of advancing citizens. Such expressions are visible now in the "emerging declarations of interdependence with all life" guiding us to safe harbor secure in a "more perfect union" governed by love's wisdom.

Peace,

Robert L. Davis, IV
Daynal Institute Press

Readers's Notes